THE
Disney
POS
THE ANIMATED

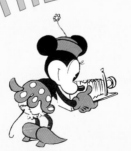
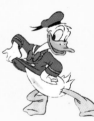

A DISNEY MINIATURE

TER

ILM CLASSICS

FROM
MICKEY MOUSE
TO ALADDIN

A WELCOME BOOK

HYPERION

NEW YORK

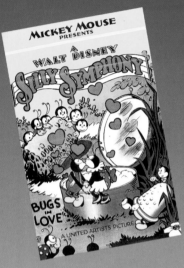

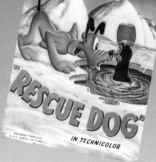

CONTENTS

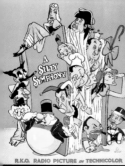

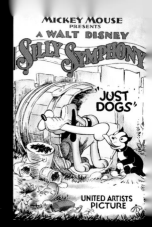

**MOTHER GOOSE GOES
HELLYWOOD** DECEMBER 23, 1938

JUST DOGS
JULY 30, 1932

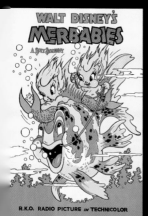

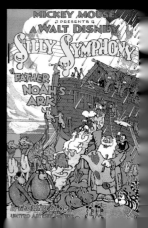

SILLY SYMPHONIES

By 1929 the formula for a successful animated short was well established. Familiar characters, a story, and specific high points for gags were standard features that moviegoing audiences could count on. When Walt Disney premiered the first of his Silly Symphonies, *The Skeleton Dance*, he broke the mold. "By nature I'm an experimenter," explained Disney. "So with the success of Mickey, I was determined to diversify. I went ahead with the idea of making a series of cartoons based on musical themes, without a central character." Film distributors and exhibitors were unenthusiastic: "Send more mice!" they cried.

Undaunted, Disney independently convinced two prestigious theaters to book *The Skeleton Dance*. Audiences were enthralled with the bony ballet, but exhibitors remained cautious. To assuage their fears, Disney borrowed on the phenomenal popularity of Mickey Mouse to sell the new series. "Mickey Mouse

SANTA'S WORKSHOP
DECEMBER 10, 1932

Presents a Walt Disney Silly Symphony," the posters proclaimed.

What really put the Silly Symphonies on the map was color. In 1932 Disney saw a test of a new three-color process that, unlike its two-color predecessor, opened up the full chromatic spectrum. He took a financial risk on the unproven process, securing exclusive rights to three-strip Technicolor for two years, although his new distributor, United Artists, would not pay more for a short in color than for one in black and white.

Disney scrapped the half-completed symphony *Flowers and Trees* in order to redo it in color, complete with a full-spectrum rainbow. Just as he had anticipated, *Flowers and Trees* created a sensation when it was released in 1932. The first cartoon to win an Academy Award, it opened up a new category in the process.

The colors in the poster for *Flowers and Trees* reflect the delicate pastels of the early Silly Symphonies. Disney perfected his palette as he went, developing brighter pigments and inventing paints that would not fade under hot lights or chip off the transparent acetate used in animation production. Film

critic Pauline Kael later described the brilliant hues as "so bright and clear that kids' eyes popped open."

The popularity of the series is credited with saving Technicolor from bankruptcy, but the Silly Symphonies were not merely a showcase for the Technicolor process; they were Disney's proving ground for new techniques and effects. Using the Symphony format, the Disney artists pioneered camera angles and complicated perspective shots, and developed increasingly natural-looking techniques for animating water reflections, rain, and flames. The addition of shading increased the sense of dimension, and more realistic human figures began to appear, especially as Disney started planning his first animated feature.

The Silly Symphonies gave Disney and his artists the opportunity to raise character animation—the art of infusing drawings with personality through movement—to new heights. Increasingly complex stories—from *Bugs in Love* and *Birds in the Spring* to the classic tales *King Neptune* and *Babes in the Woods*—allowed the animators to perfect the subtlety of movement needed to convey a wide variety of emotions.

The Silly Symphonies are alive with the enthusiastic energy of young artists exploring a new art form, and the symphony posters radiate that same creative excitement. The poster artists couldn't mirror much of the melody or movement that defined the films, but they did capture the kaleidoscope of rich colors and the array of outrageous characters. The poster for *Merbabies* centers on a strong yet simple image communicating the sense of fun in this undersea fantasy, and the poster for one of the last symphonies, *Mother Goose Goes Hollywood*, features elegant caricatures designed for the film by the improbably but appropriately named T. Hee.

The Silly Symphonies paved the way for Disney features such as *Snow White and the Seven Dwarfs* and especially *Fantasia*, which owes its entire concept to the symphonies. Walt Disney phased out the artistically groundbreaking Silly Symphonies in 1939, ending an award-winning series that remains unmatched in the animation field.

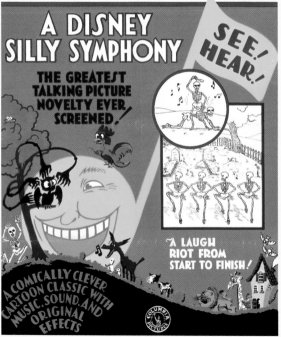

THE SKELETON DANCE
MAY 10, 1929

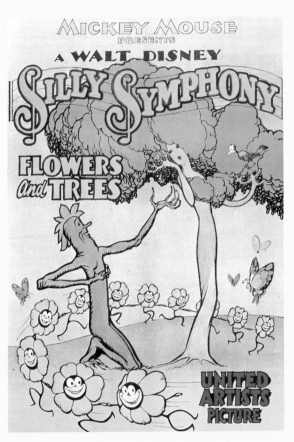

FLOWERS AND TREES
JULY 30, 1932

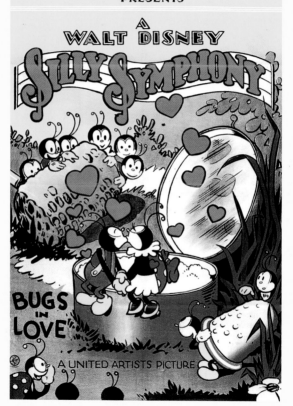

BUGS IN LOVE
OCTOBER 1, 1932

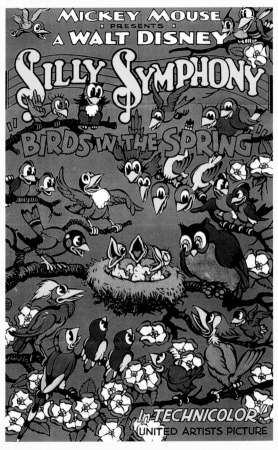

BIRDS IN THE SPRING
MARCH 11, 1933

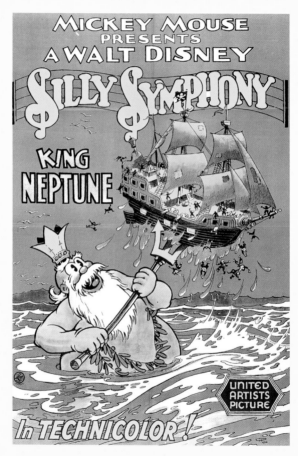

KING NEPTUNE
SEPTEMBER 10, 1932

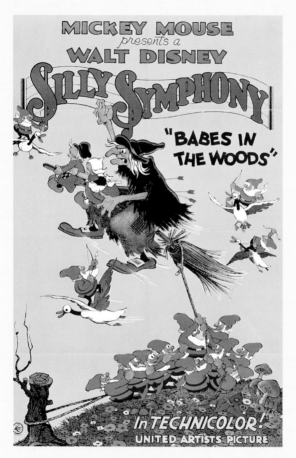

17

BABES IN THE WOODS
NOVEMBER 19, 1932

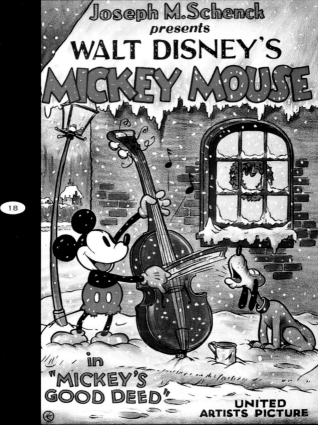

JUST MICKEY

"I only hope that we never lose sight of one thing," Walt Disney once said. "It was all started by a mouse." Mickey Mouse is firmly fixed in our minds as the personification of Disney's magical kingdom, and the vibrant posters that proclaimed the advent of each new Mickey Mouse cartoon endure as vivid testaments to his enormous appeal.

One of Disney's earliest associates, animator Ub Iwerks, established the mouse's design, and Iwerks receives credit for Mickey in early films such as *Wild Waves*. But it was Disney himself who provided Mickey's personality, his voice, and his very soul.

When introduced in 1928, Disney's brainchild proved an overnight sensation. Throughout much of the 1930s, Mickey Mouse reigned as Hollywood's number-one star, outdrawing even perennial box-office leaders Clark Gable and Mickey Rooney. Many a movie marquee billed Mickey's cartoons above the

THE MAD DOG
FEBRUARY 27, 1932

so-called main attraction.

The key to his tremendous appeal is his simplicity. As Disney explained: "Mickey is so simple and uncomplicated, so easy to understand that you can't help liking him." Yet artists have long held that when it comes to this Mouse's magnetism, something deeper is afoot. Andy Warhol and Roy Lichtenstein both borrowed the familiar image for important pieces; award-winning writer-illustrator Maurice Sendak has called Mickey "a piece of art that powerfully affected and stimulated the imagination." Sculptor Ernest Trova raised him to the status of twentieth-century cultural icon when he declared the three most powerful graphic images of this century to be the swastika, the Coca-Cola bottle, and Mickey Mouse.

The most casual glance at Mickey's movie posters reveals the power of the Mouse as, in Sendak's words, "pure graphic image." Intended as promotional vehicles, the posters are striking works of art in themselves. The earliest, from the period of distribution by Columbia Pictures (pre-1931), seem intent on establishing Mickey Mouse's early talkie superstar status, trumpeting such slogans as "He Sings! He Talks! He Dances!" and "The World's Funniest Cartoon

Character." Since Mickey's pre-1935 films were in black and white, it was the posters that introduced the public to the brilliant reds and yellows that would become the Mouse's signature colors.

The posters trace Mickey's evolution from mischievous barnyard merrymaker to established suburban citizen. In the films released by United Artists (1932–1937), early preoccupations such as the farmland frolics in *Barnyard Olympics* and let's-put-a-show-on-in-the-barn variety turns such as *Mickey's Revue* gave way to greater adventure, as the Mouse's restless heart led him further afield.

The later, RKO-period posters (1937–1956) move away from literal interpretation of plots to ever more artful expression of the spirit of the films. The greater sophistication in poster design parallels the increasing refinement of the character animation. "Mickey provided the means for expanding our organization to its present dimension," Disney noted, "and for extending the medium of cartoon animation towards new entertainment levels." Mickey Mouse is not a broad comedy character; it required a great deal of skill to animate his nice-guy mannerisms and simple sense of fun, and without him, there would have been

no Silly Symphonies, and no features.

Mickey's physical appearance changed over the years, as the studio sought to make him more expressive. Master Disney animator Fred Moore is credited with having developed a pear-shaped body and a more flexible face for the Mouse; the button eyes acquired pupils in 1939. As Mickey's look evolved in the films, the posters followed suit, providing a graphic history of his "cosmetic surgery."

Although Mickey Mouse starred in his last short, *The Simple Things*, in 1953, he remains the most popular cartoon character in the world. Whatever his fame or fortune, Mickey is still the adventurous, somewhat shy, completely unaffected mouse next door. "All we ever intended for him or expected of him was that he should continue to make people everywhere chuckle with him," said Walt Disney. "Mickey was simply a little personality assigned to the purpose of laughter."

THE MAD DOCTOR
JANUARY 21, 1933

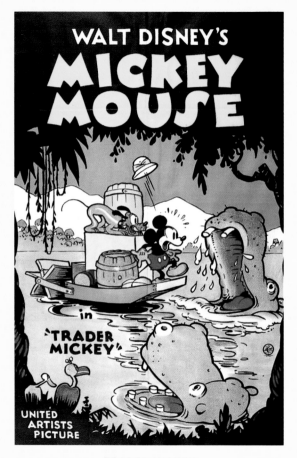

TRADER MICKEY
AUGUST 20, 1932

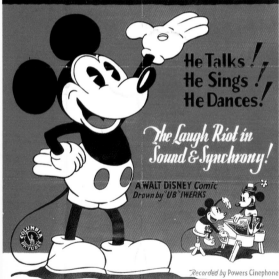

WILD WAVES
DECEMBER 21, 1929

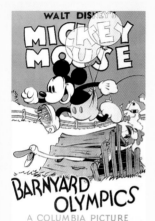

BARNYARD OLYMPICS
APRIL 13, 1932

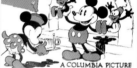

MICKEY IN ARABIA
JULY 11, 1932

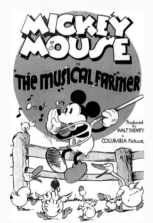

MUSICAL FARMER
JUNE 8, 1932

MICKEY'S REVUE
MAY 12, 1932

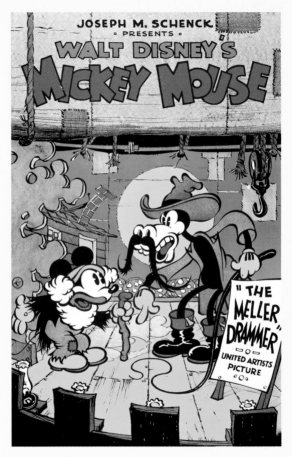

MICKEY'S MELLERDRAMMER
MARCH 18, 1933

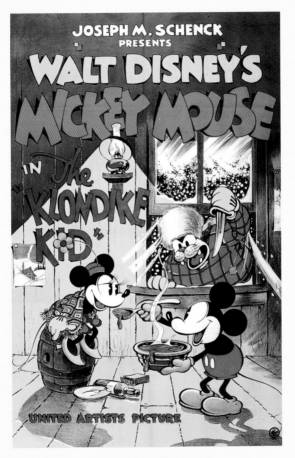

THE KLONDIKE KID
NOVEMBER 12, 1932

JOSEPH M. SCHENCK
: PRESENTS :
WALT DISNEY'S
MICKEY MOUSE

The
WAYWARD CANARY
□ UNITED ARTISTS PICTURE □

THE WAYWARD CANARY
NOVEMBER 12, 1932

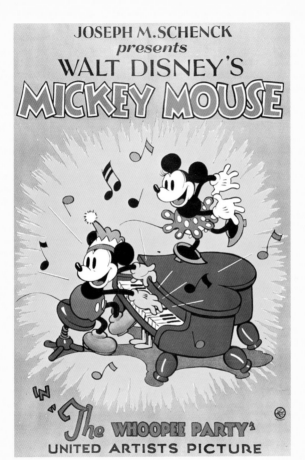

THE WHOOPEE PARTY
SEPTEMBER 17, 1932

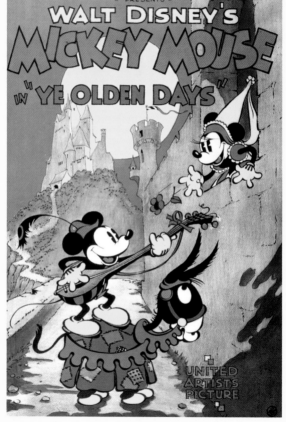

YE OLDEN DAYS
APRIL 8, 1933

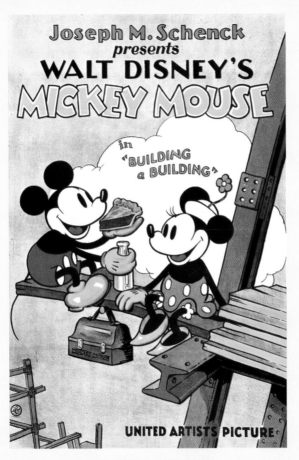

BUILDING A BUILDING
JANUARY 7, 1933

MICKEY'S NIGHTMARE
AUGUST 13, 1932

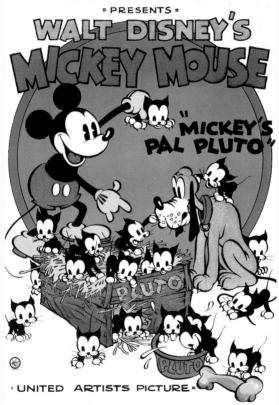

35

MICKEY'S PAL PLUTO
FEBRUARY 18, 1933

MR. MOUSE TAKES A TRIP
NOVEMBER 1, 1940

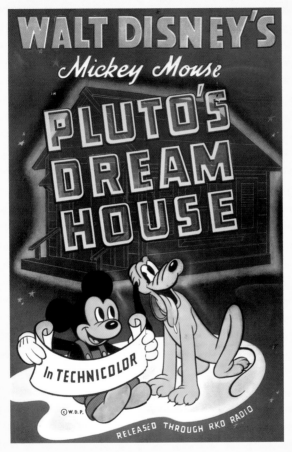

PLUTO'S DREAM HOUSE
AUGUST 30, 1940

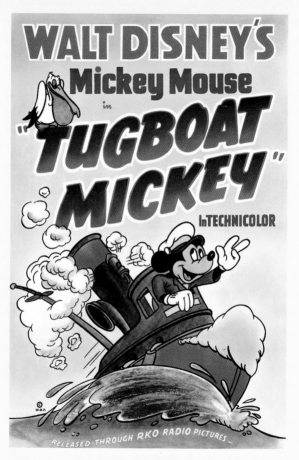

TUGBOAT MICKEY
APRIL 26, 1940

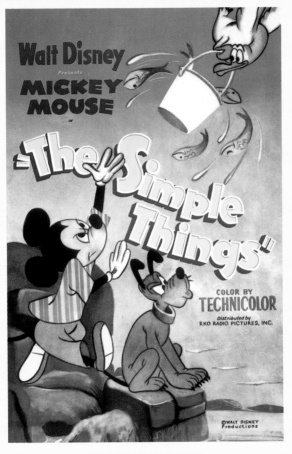

THE SIMPLE THINGS
APRIL 18, 1953

CANINE CADDY
MAY 30, 1941

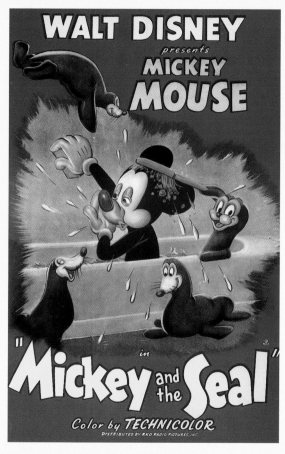

41

MICKEY AND THE SEAL
DECEMBER 3, 1948

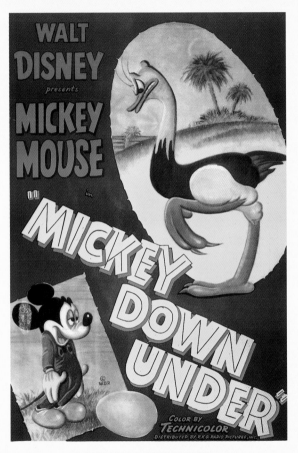

MICKEY DOWN UNDER
MARCH 19, 1948

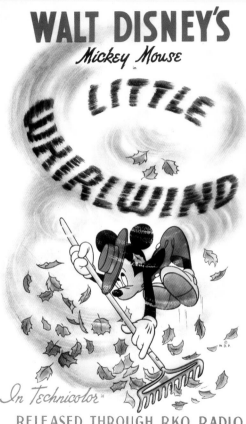

THE LITTLE WHIRLWIND
FEBRUARY 14, 1941

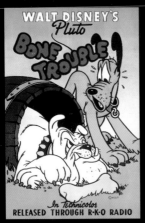

BONE TROUBLE
JUNE 28, 1940

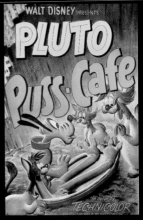

PUSS-CAFE
JUNE 9, 1950

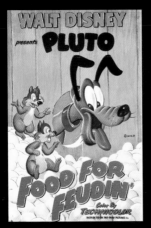

FOOD FOR FEUDIN'
AUGUST 11, 1950

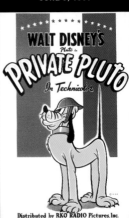

PRIVATE PLUTO
APRIL 2, 1943

MICKEY'S PAL PLUTO

For Pluto it's strictly a dog's life. Unlike shorts starring his compatriots, in which the stars have exotic adventures in remote times and places, Pluto's pictures center mostly on the typical backyard escapades of the ordinary household pooch. "We've kept Pluto all dog," said veteran Pluto animator Nick Nichols. The seemingly endless amusing variations on that theme which Pluto's animators devised are impressive. Disney and his animation crew concocted a kennelful of situations and supporting characters to tangle with the dog.

Pluto evolved from a pair of bloodhounds into a canine with the uninspired name of Rover in early Mickey Mouse shorts before he was collared as a permanent pet for the Mouse. Disney based Pluto on the farm hounds he knew in his youth. Homer the Hound and Pal were two names suggested for the

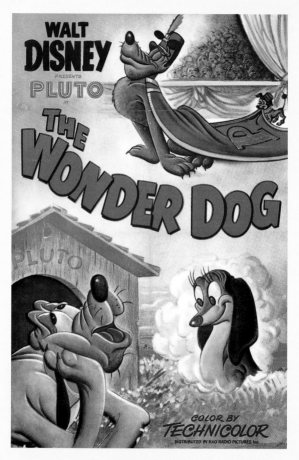

WONDER DOG
APRIL 7, 1950

developing character, but Disney ultimately dubbed him Pluto the Pup. His rise to dog star status happened quickly; he is prominent in many of the early Mickey shorts and began to star in his own series in 1937.

Pluto's best moments occur when he finds himself in situations that force him to react to circumstances beyond his control. His early scrapes with inanimate objects provided some very funny moments in the Mickey Mouse shorts, and Pluto's sniffing, snorting, yelping, and scratching all became trademarks. Extended battles with stubborn stuff, such as the nearly animate bubble gum that plagued him in *Bubble Bee*, became a mainstay of the Pluto vehicles. Indeed, his singular manner of reacting inaugurated a leap forward in the art of character animation: Pluto began to think.

Early cartoon characters conveyed thought only through the crudest movements or symbols; they simply reacted to events. Without the ability to display reasoning, animated characters would never seem convincingly alive. Through Norm Ferguson's inspired animation, Disney's dog broke the thought barrier by stopping to ponder, in his own uncomprehending

way, whatever sticky situation he faced.

Pluto's slow mental deliberations proved a cornerstone of the entertainment. Audiences found his curiosity and sluggish thought processes as endearing as did Disney. "The character wasn't out just bouncing around to music or acting out a gag. The humor was built out of the situation of Pluto trying to extricate himself from his predicament, rather than a simple gag tableau," observed Disney animator Ward Kimball. The dog's persistent mental puzzlement laid the groundwork for animators to create characters that seemed truly to live on the screen.

The posters highlight the menagerie of tormentors the animators devised for Pluto to encounter. These include Butch the bullying bulldog, who appeared in *Bone Trouble*; Bent-Tail and Bent-Tail, Junior, the coyote father-and-son team of *Pests of the West* and other shorts; and Milton the irksome feline from *Puss-Café* and *Cold Turkey*. Those masters of mischief Chip an' Dale pestered Pluto, as did Figaro the kitten, who was originally from *Pinocchio* and was one of the few characters to cross over from feature to short. Pluto also found himself tormented—but in a different

manner—by Dinah, a beautiful female dachshund who was the lovesick mutt's heart's desire in several pictures, including *Wonder Dog*.

The poster artists concentrated on capturing Pluto's quizzical looks as he encountered puzzling situations or confronted new characters. The Pluto posters spotlight the consistency of the shorts starring "the naive, credulous hound," as Walt Disney affectionately described his canine star. Even during the war, when Mickey, Donald, and Goofy acted as surrogates for their human counterparts at home and on the front, Pluto never abandoned his role as loyal hound. Artists celebrated the patriotic pooch with the stars-and-stripes-themed poster for *Private Pluto*, one of several war-related shorts in which Pluto proudly served. Yet wherever duty called, and whatever new predicament Pluto confronted, he always remained the dog next door.

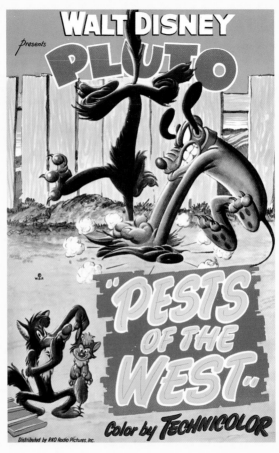

50

PESTS OF THE WEST
JULY 21, 1950

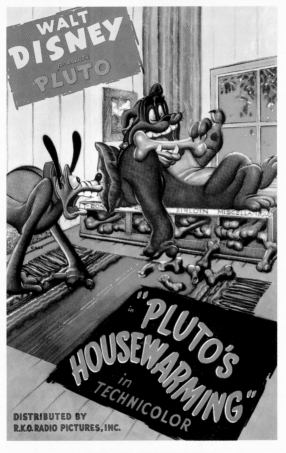

PLUTO'S HOUSEWARMING
FEBRUARY 21, 1947

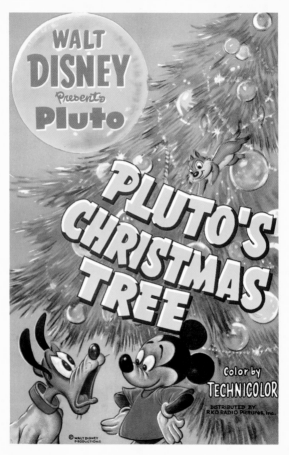

PLUTO'S CHRISTMAS TREE
NOVEMBER 21, 1952

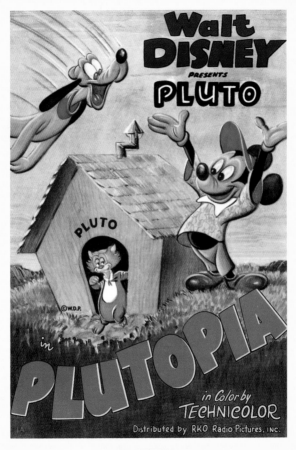

53

PLUTOPIA
MAY 18, 1951

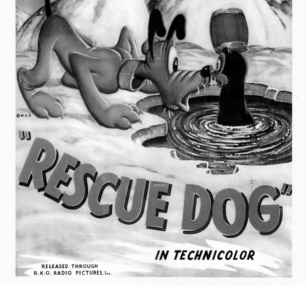

RESCUE DOG
MARCH 21, 1947

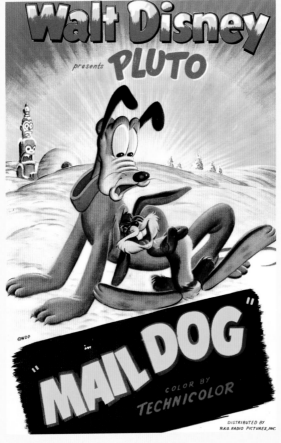

MAIL DOG
NOVEMBER 14, 1947

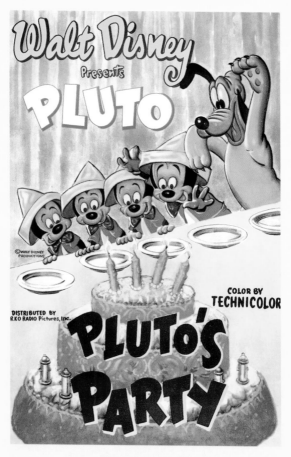

PLUTO'S PARTY
SEPTEMBER 19, 1952

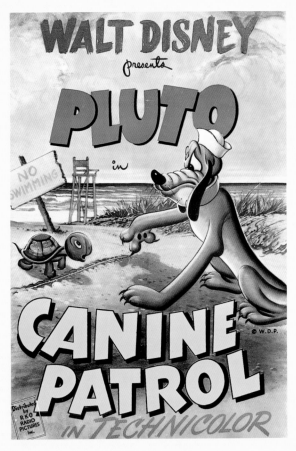

CANINE PATROL
DECEMBER 7, 1945

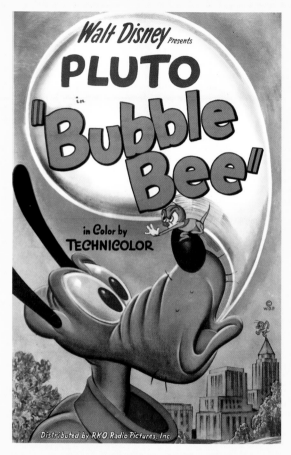

BUBBLE BEE
JUNE 24, 1949

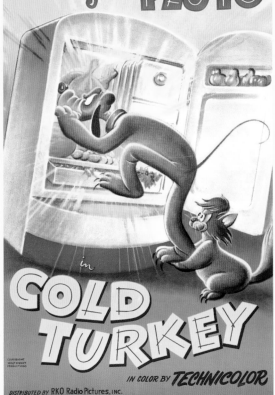

COLD TURKEY
SEPTEMBER 21, 1951

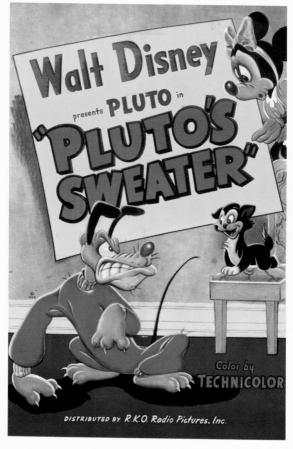

PLUTO'S SWEATER
APRIL 29, 1949

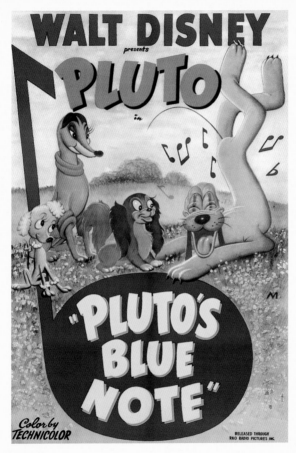

PLUTO'S BLUE NOTE
DECEMBER 26, 1947

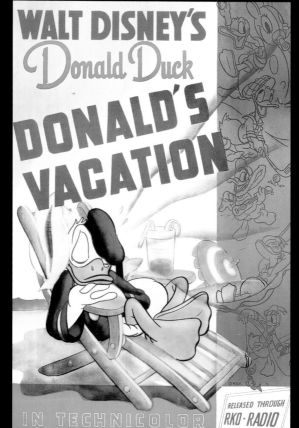

DONALD'S VACATION

DON DONALD

A star was hatched when Walt Disney heard the now famous duck voice performed by Clarence "Ducky" Nash and exclaimed: "That's our talking duck!" Donald Duck began life as a mere supporting player in a Silly Symphony, but his distinctive voice made him an instant hit. Disney quickly cast Donald in a Mickey Mouse cartoon in which the popular new star first displayed his now-familiar hot-headed temper.

Donald became a regular in the Mickey Mouse series, and his appearance evolved as his popularity soared. The animators refined the gangly, long-necked bird with pointed bill, knobby knees, and scraggly feathers into a rounder, less angular, more expressive duck. Though his features changed, certain properties remained the same; he almost always wore his sailor outfit and absolutely never cooled his monumental temper and combative nature. Audiences could

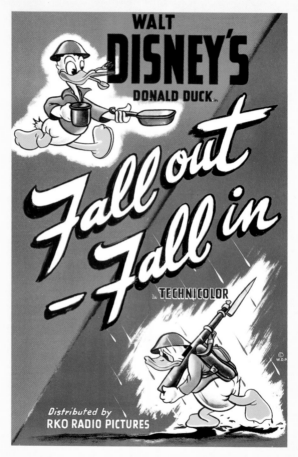

FALL OUT—FALL IN
APRIL 23, 1943

identify with Donald and his irritation with life's pesky problems, even as they laughed at the ridiculous extremes to which his rage could take him.

Donald represented something truly new on the scene. The duck was a cartoon antihero—a character who responded to any obstacle in his path with full-throated fury. Audiences loved him. By 1937 Donald's popularity had eclipsed even Mickey's. Disney's animators and story artists were finding it an increasing challenge to develop entertaining stories for Mickey, who had become something of a straight man. Donald's fiery personality, in contrast, presented all sorts of story possibilities and character conflicts. The foul-tempered fowl became a comic foil to the increasingly mild-mannered mouse. In 1936 Donald began to star in his own films, becoming only the second of Disney's pantheon (after Mickey) to do so.

Donald's bombastic frustration seemed just the right reflection of audience sentiment during the tough times of the Great Depression, but the Duck really came into his own in the 1940s. Donald's native aggressiveness was ready made for coping with wartime challenges. The Duck shared the average

citizen's exasperation with the inconveniences of the war, on both the home front and the front lines. *Donald's Tire Trouble* finds him confronting the frustrations of rubber rationing, and the poster art reflects how the Duck's misadventures literally were torn from the headlines of the day. One of Donald's early encounters with the military took place 1943 in *Fall Out-Fall In*, in which he enlisted for the duration. Donald Duck joined millions of former civilians as they struggled to cope with army life, and he gave full vent to both his frustrations and theirs.

The posters reveal the many faces of a duck who wears his feelings on the sleeve of his sailor suit. Donald's emotional versatility allowed him to respond to any situation, running the gamut of human emotions from hot to cold—and back again—in any given instant. The posters also portray a gallery of Donald's costars, many of whom the animators created just to annoy the Duck, from needling girlfriend Daisy Duck to Spike the bee to tiny nemeses Chip an' Dale—a pair of chipmunks who knew just how to trigger those famous temper tantrums. Donald even teamed up with Goofy for several memorable

encounters, such as *No Sail*, in which the Goof's oblivious idiocy drives the Duck to distraction.

Of course, it doesn't matter what opponent Donald faces; he's his own worst enemy. Donald delights in causing trouble for others, but his schemes have a way of backfiring. Self-control is the one virtue that could solve most of the Duck's problems, but audiences love him most for his lack of ability to resist inflicting disaster on himself.

At the core of Donald's stardom are his very human qualities: he's a fine, feathered everyman. Even Walt Disney, who had a special fondness for Mickey Mouse, recognized that the long-suffering Mouse had become the embodiment of an ideal being, while the Duck represented the unpolished reality. "Donald Duck is an escape, a relief from Mickey's inhibitions. He's an outrageous fellow with bad manners and a worse temper, and everyone is very fond of him, including myself."

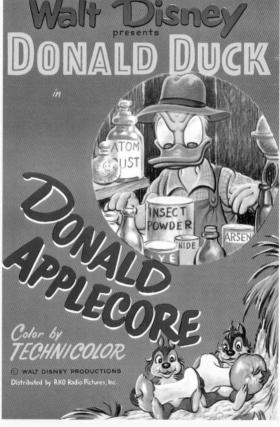

DONALD APPLECORE
JANUARY 18, 1952

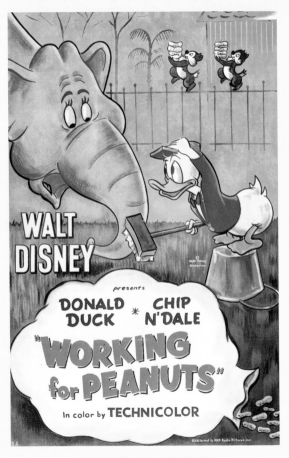

WORKING FOR PEANUTS
NOVEMBER 11, 1953

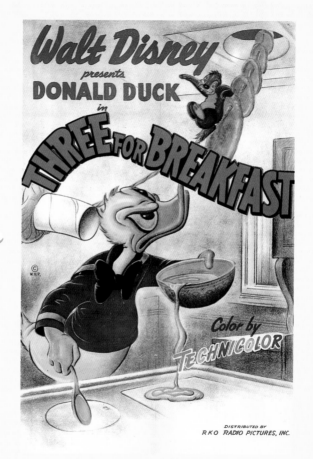

THREE FOR BREAKFAST
NOVEMBER 5, 1948

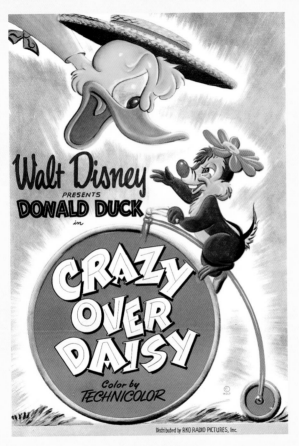

CRAZY OVER DAISY
MARCH 24, 1950

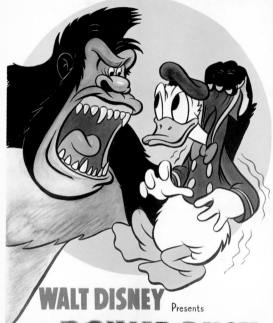

DONALD DUCK AND THE GORILLA
MARCH 31, 1944

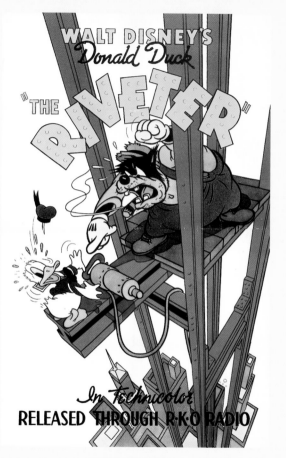

THE RIVETER
MARCH 15, 1940

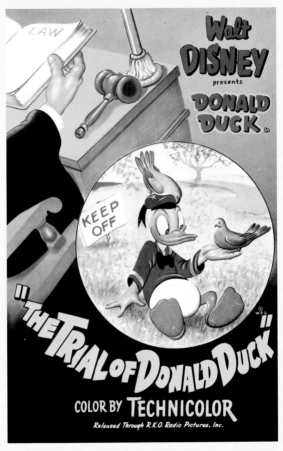

THE TRIAL OF DONALD DUCK
JULY 30, 1948

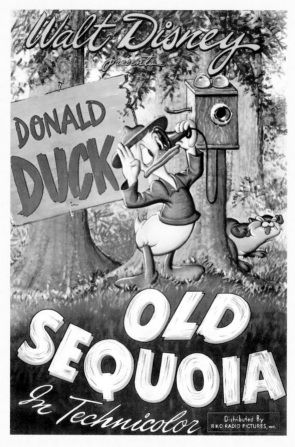

OLD SEQUOIA
DECEMBER 21, 1945

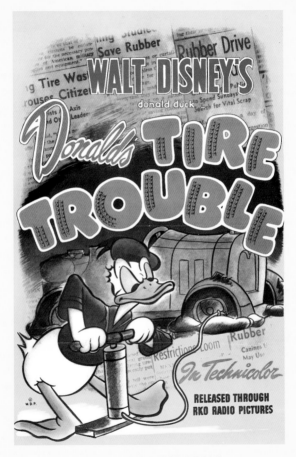

DONALD'S TIRE TROUBLE
JANUARY 29, 1943

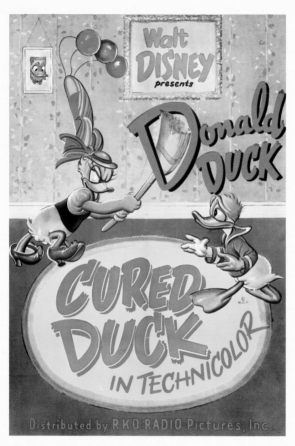

CURED DUCK
OCTOBER 26, 1945

INFERIOR DECORATOR
AUGUST 27, 1948

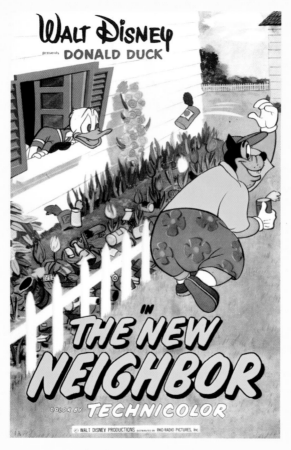

THE NEW NEIGHBOR
AUGUST 1, 1953

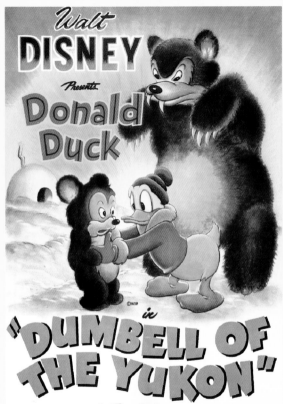

DUMB BELL OF THE YUKON
AUGUST 30, 1946

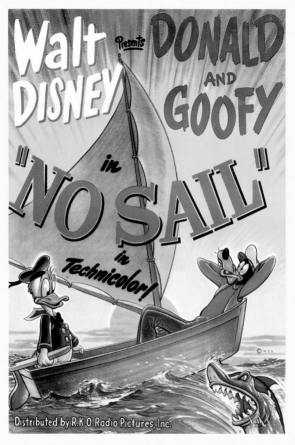

81

NO SAIL
SEPTEMBER 7, 1945

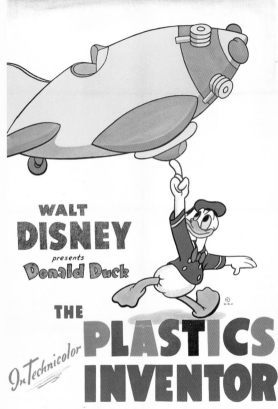

WALT
DISNEY
presents
Donald Duck

THE
PLASTICS
In Technicolor INVENTOR

DISTRIBUTED BY RKO RADIO PICTURES, INC

THE PLASTICS INVENTOR
SEPTEMBER 1, 1944

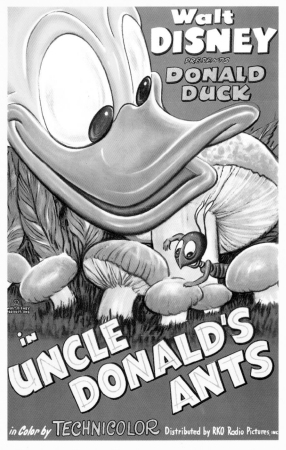

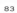

UNCLE DONALD'S ANTS
JULY 18, 1952

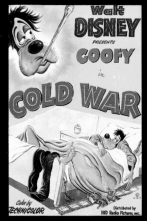

TWO WEEKS VACATION
OCTOBER 31, 1952

COLD WAR
APRIL 27, 1951

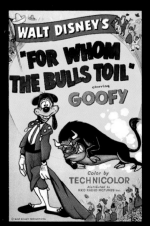

A KNIGHT FOR A DAY
MARCH 8, 1946

FOR WHOM THE BULLS TOIL
MAY 9, 1953

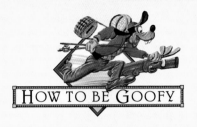

HOW TO BE GOOFY

The Goofy who inhabits our collective psyche is the eager to please, helpful, but hopelessly inept country bumpkin best known as Mickey Mouse's costar. When Goofy became a top-billed star in his own series of cartoons, that original buffoonish persona turned out to be only the jumping-off point. A creature of unexpected versatility, Goofy has had the most varied screen career of any star in the Disney stable. When Mickey played the Sorcerer's Apprentice or Donald starred in a period piece such as *Crazy over Daisy*, their personalities remained basically constant. But Goofy not only appeared in a variety of settings and periods, he took on different personas, sometimes going so far as to play every part in the picture. Who would have guessed it would be Goofy, of all the Disney players, who possessed the dramatic range to be a character actor?

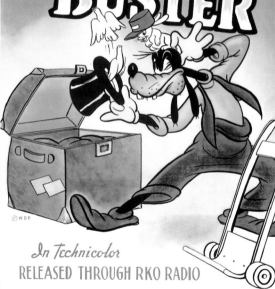

BAGGAGE BUSTER
APRIL 18, 1941

Like Donald, Goofy made his screen debut as a bit player with a trick voice, appearing in 1932 in *Mickey's Revue*, as a chinless, whiskered rube, simplemindedly laughing at the on-stage antics. His distinctive guffaw, provided by story man and voice artist Pinto Colvig, suggested comic possibilities, so Walt Disney cast Goofy (originally christened Dippy Dawg) in more of Mickey's films. Greater screen exposure called for a new look, so the Disney artists gave the Goof a star makeover, endowing him with shoulders, a chin, a simplified but more expressive face, and the desire, if not the ability, to think for himself. Story artists were quick to exploit Goofy's slow-motion mind, realizing he was at his most entertaining when he tried to comprehend something beyond his mental grasp.

By 1936 Goofy had become a true star. When Disney began to create individual series for each of his major players late in the decade, Goofy at first appeared as his old knockabout self in such shorts as *Goofy's Glider* and *Baggage Buster*. About this time, however, Pinto Colvig left the studio, taking the character's voice with him. The Disney animators scurried to find a new format for their suddenly silent

star. Jack Kinney, director of many Goofy cartoons, came up with the answer: cast the accident-prone Goofy as an improbable how-to expert who would "goof up" each directive issued by a serious, oblivious narrator. "The 'how-to' format opened up a vast area," recalled Kinney. "The subject matter could be anything; do-it-yourself repairs, or even the wide world of sports, all open to Goofy's dum-dum exploration." This inspired idea led to the creation of such well-loved, if seldom heeded, instructional films as *How to Fish*, *The Art of Self Defense*, and *How to Swim*, which dominated Goofy's movie output of the 1940s.

The 1950s saw the rise and growing dominance of television, as well as the simultaneous growth of bedroom communities and suburbs. The burgeoning popularity of TV family comedies influenced all of Disney's characters (Mickey and Donald both became suburban homeowners, for example), but none more so than Goofy. Beginning another phase of his screen career, the Goof was now cast as a harried husband and office worker in a series of domestic sitcoms— a sort of animated "Father Knows Least."

As he settled into his 1950s suburban lifestyle,

Goofy's look changed. The poster for *Cold War* mirrors the alteration in his design: his dog ears and buck teeth are all but eliminated. Marking his second major design overhaul, this visual transformation completed Goofy's transition from Mickey's barnyard buddy to an actor portraying Mr. Geef, a put-upon middle-class suburbanite. The ambiguity of his ultimate appearance perhaps evoked the confusion immortalized in the 1986 film *Stand By Me*: "If Mickey's a mouse, Donald's a duck, and Pluto's a dog, then what's Goofy?" Disney animator Ward Kimball explained: "Goofy became our resident *Homo sapiens*—with a dog face—our man who represented the common humanoid. It was Goofy against the world." Yet, different as his later comic roles and look were from his classic personality, the Goof always retained a hint of the original good-natured hayseed—enough that audiences could still recognize him as good old Goofy.

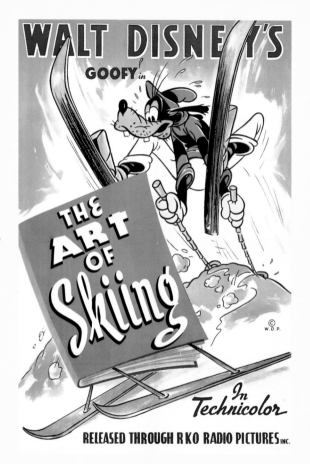

THE ART OF SKIING
NOVEMBER 14, 1941

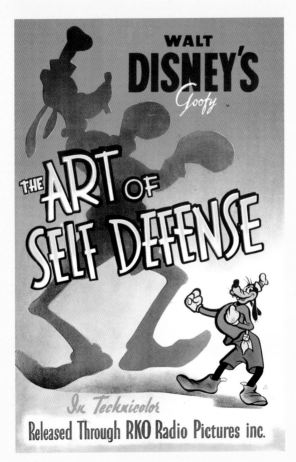

THE ART OF SELF DEFENSE
DECEMBER 26, 1941

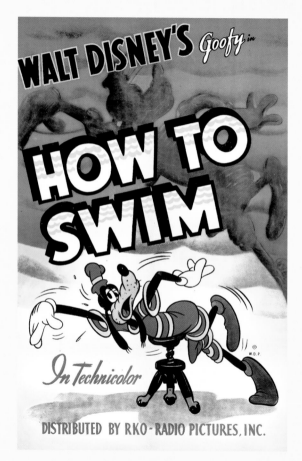

HOW TO SWIM
OCTOBER 23, 1942

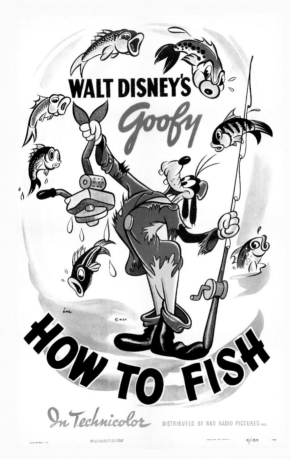

HOW TO FISH
DECEMBER 4, 1942

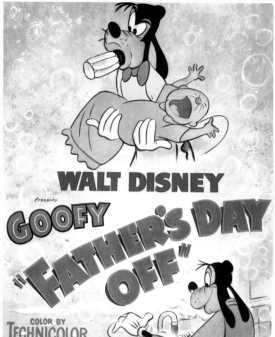

FATHER'S DAY OFF
MARCH 28, 1953

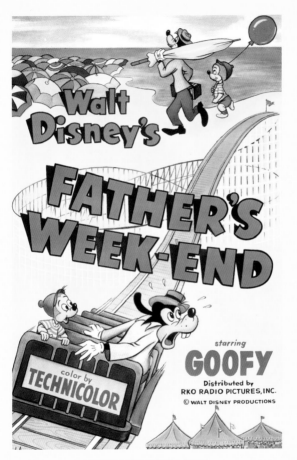

FATHER'S WEEK END
JUNE 20, 1953

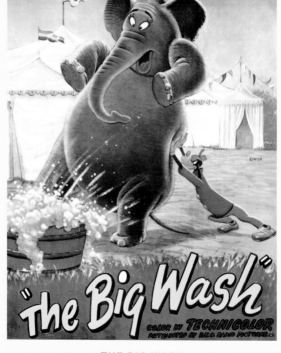

96

THE BIG WASH
FEBRUARY 6, 1948

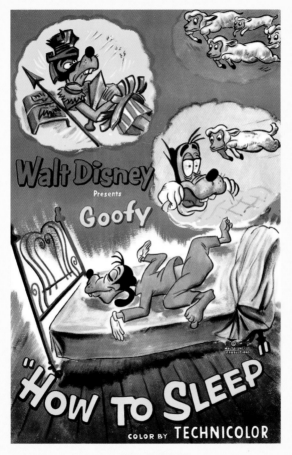

HOW TO SLEEP
DECEMBER 25, 1953

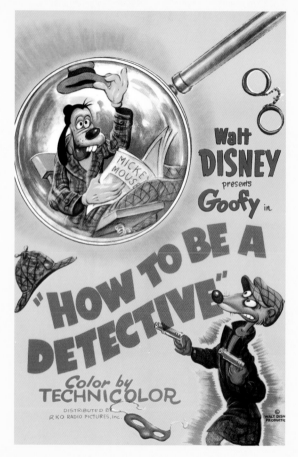

HOW TO BE A DETECTIVE
DECEMBER 12, 1952

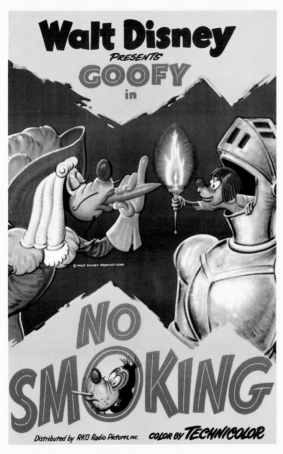

NO SMOKING
NOVEMBER 23, 1951

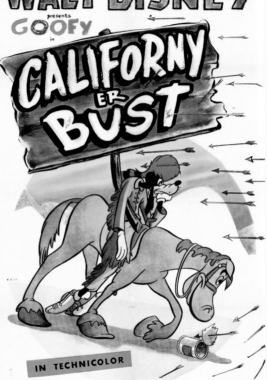

CALIFORNY ER BUST
JULY 13, 1945

MONDAY

Walt Disney

presents GOOFY *in*

African Diary

101

IN TECHNICOLOR

DISTRIBUTED BY RKO RADIO PICTURES INC.

AFRICAN DIARY
APRIL 20, 1945

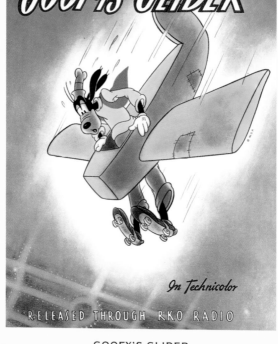

GOOFY'S GLIDER
NOVEMBER 22, 1940

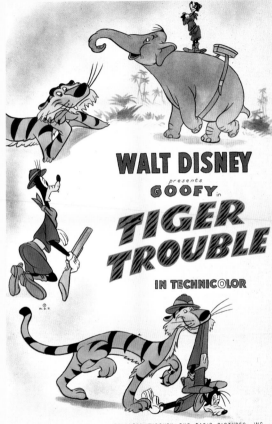

WALT DISNEY

presents

GOOFY in

TIGER TROUBLE

IN TECHNICOLOR

RELEASED THROUGH RKO RADIO PICTURES, INC.

TIGER TROUBLE
JANUARY 5, 1945

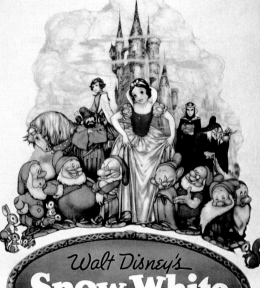

HIS FIRST FULL LENGTH FEATURE PRODUCTION

Walt Disney's
Snow White
and the Seven Dwarfs
in the Marvelous
MULTIPLANE TECHNICOLOR

© W D P

Distributed by RKO Radio Pictures, Inc.

THE CLASSIC FEATURES

"Animation can explain whatever the mind of man can conceive," Walt Disney once noted. "This facility makes it the most versatile and explicit means of communication yet devised for mass appreciation." The potential of animation was almost completely untapped when Disney created Mickey Mouse in 1928, but by the time *Snow White and the Seven Dwarfs* was released a decade later, Disney had developed what was once a crude novelty into an art form capable of expressing emotion, atmosphere, and personality. The wide canvas on which he brushed the strokes of great character and effects animation was the animated feature. From *Snow White* to *Aladdin*, the Disney features present unforgettable stories and characters that live in audiences' imaginations for a lifetime.

As early as 1934 Walt Disney made the seemingly unthinkable decision to produce Snow White as a full-length animated film. Hollywood skeptics branded the

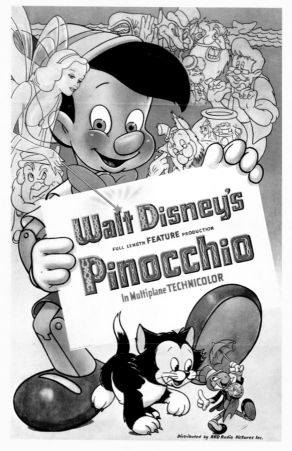

PINOCCHIO
FEBRUARY 7, 1940

project "Disney's Folly," contending that audiences wouldn't sit still for a whole feature's worth of cartoon antics, but Disney's vision far outstripped his critics'. He imagined a fully developed story with vivid characters, rich atmosphere, and dynamic filmmaking to top even the finest live-action production.

His artists were not yet skilled enough to create such sophisticated animation, so Disney provided art training classes, and opportunities to experiment in early short films. To portray the lovable dwarfs and the sweetly innocent Snow White, Disney inspired his team to achieve more emotive "acting" in their drawings and to capture the elusive grace of the human form. Completed in 1937 after three years of intense production, *Snow White* captured hearts and imaginations around the world with its endearing characters and beautiful artistry. It was a smash hit, quickly becoming the most popular film made to date.

With each new film they produced, Disney and his team developed ideas that changed the face of animation. The experimental combination of classical music and animation in *Fantasia*, for example, required a different artistic sensibility from its predecessors. The resulting feast of powerful visual

imagery fused with symphonic sound makes the case for the ability of animation to bring anything imaginable to life.

With *Bambi*, Disney took a creative leap in an entirely different direction, by telling the gentle story of a deer's life through groundbreaking, naturalistic animation. The subtle, understated style makes *Bambi* an emotional experience for all who see it. Yet the convincing portrayal of such high drama as the death of Bambi's mother would have been inconceivable just a few years earlier.

Sometimes both technology and the tenor of the times drove the creative process forward. In the 1960s the advent of the photocopier eliminated the step of hand-tracing pencil drawings, and made it possible to preserve the spontaneity of the animators' original work. The sketchy look that resulted perfectly suited the decidedly contemporary *One Hundred and One Dalmatians*. The enduring appeal of the film stems from the involving drama of the purloined puppies and the wildly caricatured Cruella De Vil, one of Disney's most hissable villains.

The current renaissance of Disney feature animation has been heralded by such films as *The*

Little Mermaid. Animated by a new generation of Disney artists, the new crop of films continues to expand the medium through deeper character insights and more sophisticated stories. No longer considered the sole province of family audiences, the animated feature has truly come into its own, with filmgoers both young and old responding to such films as *Beauty and the Beast* and *Aladdin* with equal enthusiasm.

The overwhelming success of these films is reflected in their unprecedented acclaim: *Beauty and the Beast* was the first animated feature to receive an Academy Award nomination for Best Picture, and *Aladdin*, an action adventure with contemporary comedy, striking design, and timeless romance, has made history as the highest grossing animated film of all time. Feature animation, Disney style, appeals to the eye and tickles the funny bone, but mostly, it speaks to the heart. The living legacy of Walt Disney's original bold vision, it is an art form that continues to evolve and to touch new generations.

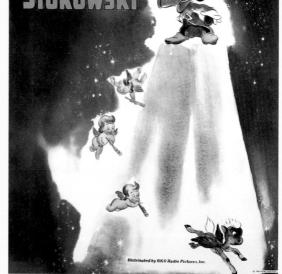

FANTASIA
NOVEMBER 13, 1940

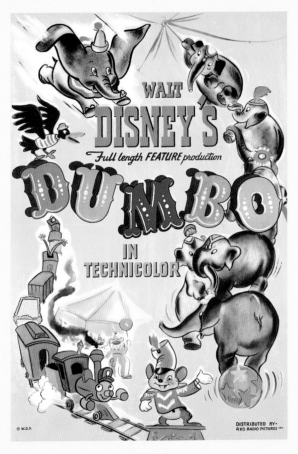

DUMBO
OCTOBER 23, 1941

TWITTERPATED?

A WISE OLD OWL TALKS ABOUT LOVE!

IF you're walking on air because she looks at you "THAT" way . . .

WHEN your head's in the clouds because your heart's in a whirl

AND if you can't eat, can't sleep, can't think because the love bug's got you

BROTHER, you're *TWITTERPATED!* and when you're "Twitterpated" you're sunk! . . .

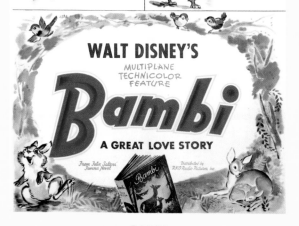

WALT DISNEY'S

MULTIPLANE TECHNICOLOR FEATURE

Bambi

A GREAT LOVE STORY

From Felix Salten's Famous Novel

Distributed by RKO Radio Pictures, Inc.

BAMBI
AUGUST 13, 1942

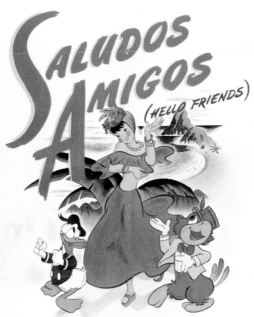

SALUDOS AMIGOS
FEBRUARY 6, 1943

THE THREE CABALLEROS
FEBRUARY 3, 1945

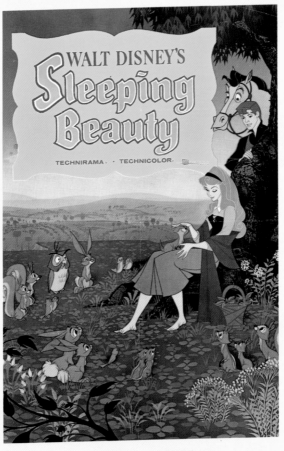

SLEEPING BEAUTY
JANUARY 29, 1959

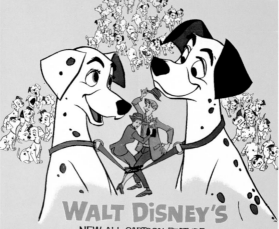

ONE HUNDRED AND ONE DALMATIANS
JANUARY 25, 1961

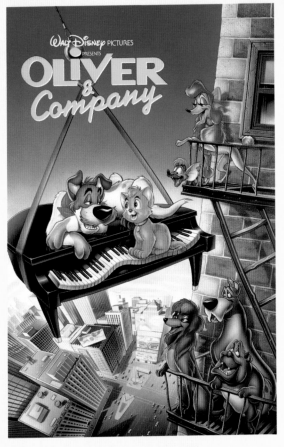

OLIVER & COMPANY
NOVEMBER 18, 1988

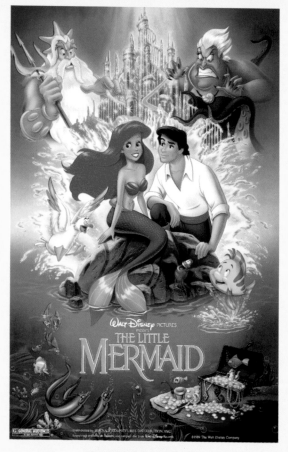

THE LITTLE MERMAID
NOVEMBER 17, 1989

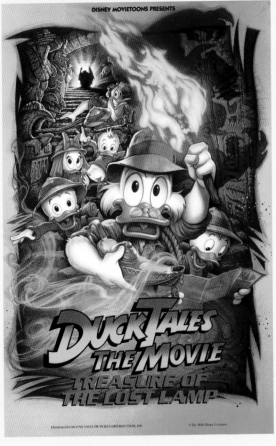

DUCKTALES: THE MOVIE
TREASURE OF THE LOST LAMP
AUGUST 3, 1990

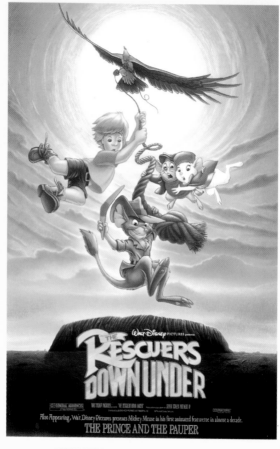

THE RESCUERS DOWN UNDER
NOVEMBER 16, 1990

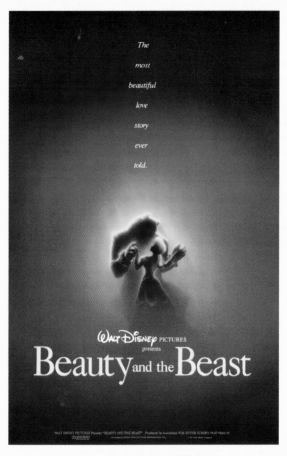

BEAUTY AND THE BEAST
NOVEMBER 22, 1991

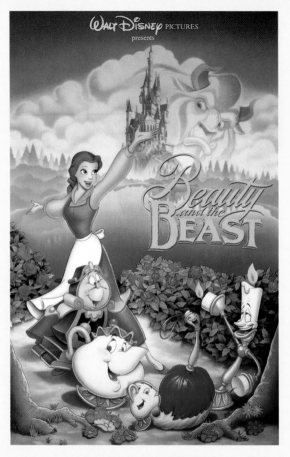

BEAUTY AND THE BEAST
NOVEMBER 22, 1991

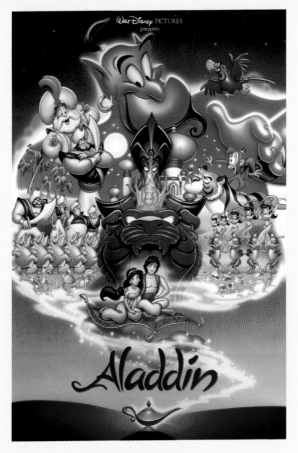

ALADDIN
NOVEMBER 25, 1992

CHRONOLOGY

* Indicates date of delivery to the
distributor; all others are date of
release.

ACKNOWLEDGMENTS

TO DAVE SMITH AND HIS STAFF AT THE WALT DISNEY ARCHIVES
(ROBERT TIEMAN, ROSE MOTZKO, AND MICHAEL TROYAN)
FOR PROVIDING MOST OF THE POSTERS AND MUCH GUIDANCE.

TO JOHN WAYNE SAFFRO
FOR GRANTING ACCESS TO HIS POSTER COLLECTION.

TO MICHAEL STERN
FOR PHOTOGRAPHING THE MAJORITY OF THE POSTERS IN THIS BOOK.

TEXT BY JIM FANNING
TEXT COPYRIGHT © 1993 HYPERION
ALL IMAGES COPYRIGHT © 1993 THE WALT DISNEY COMPANY.
SNOW WHITE (P. 1), *FANTASIA* (P. 110), *DUMBO* (P. 111),
AND *BAMBI* (P. 112) APPEAR COURTESY OF JOHN WAYNE SAFFRO.

FOR INFORMATION ADDRESS: HYPERION
114 FIFTH AVENUE, NEW YORK, NEW YORK 10011

ISBN 0-7868-6185-1
"A DISNEY MINIATURE" EDITION

PRODUCED BY: WELCOME ENTERPRISES, INC.
575 BROADWAY, NEW YORK, NEW YORK 10012
PROJECT DIRECTOR: HIRO CLARK
EDITOR: ELLEN MENDLOW
DESIGNER: MARY TIEGREEN

NOTE: THE NAMES OF THE FILMS AS THEY APPEAR ON THE POSTERS ARE
OCCASIONALLY INACCURATE. THE CORRECT NAME OF EACH FILM IS LISTED BELOW
THE POSTER ALONG WITH THE RELEASE DATE, OR WHEN THE RELEASE DATE IS
UNAVAILABLE, THE DATE OF DELIVERY TO THE DISTRIBUTOR.

PRINTED AND BOUND IN SINGAPORE BY TIEN WAH PRESS

1 3 5 7 9 10 8 6 4 2